D0581767

ANIMALS THAT SAW YOU

NAKED

CHARLIE
ELLIS

summersdale

ANIMALS THAT SAW YOU NAKED

Summersdale Publishers Ltd
46 West Street
Chichester
West Sussex
PO19 1RP
UK

www.summersdale.com

Printed and bound in China

ISBN: 978-1-84953-768-1

Substantial discounts on bulk quantities of Summersdale books are available to corporations, professional associations and other organisations. For details contact Nicky Douglas by telephone: +44 (0) 1243 756902, fax: +44 (0) 1243 786300 or email: nicky@summersdale.com.

TO...

FROM...

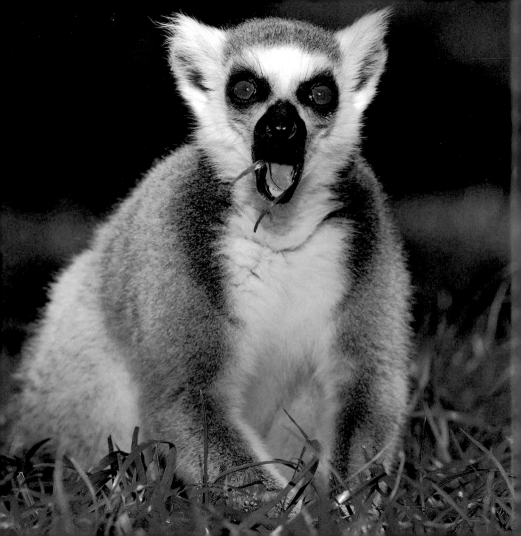

YOUR BODY IS

JAW-DROPPING...

BUT NOT IN A GOOD WAY.

NUTS!

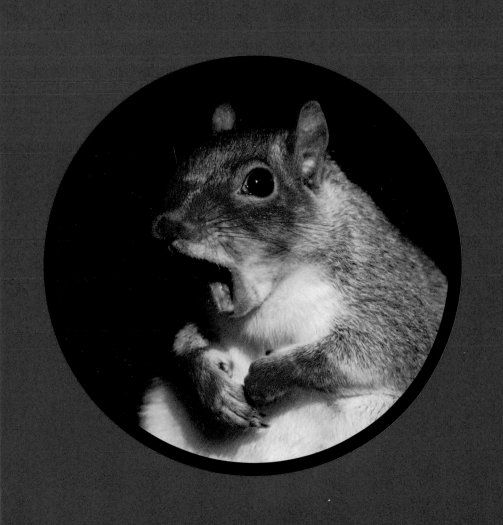

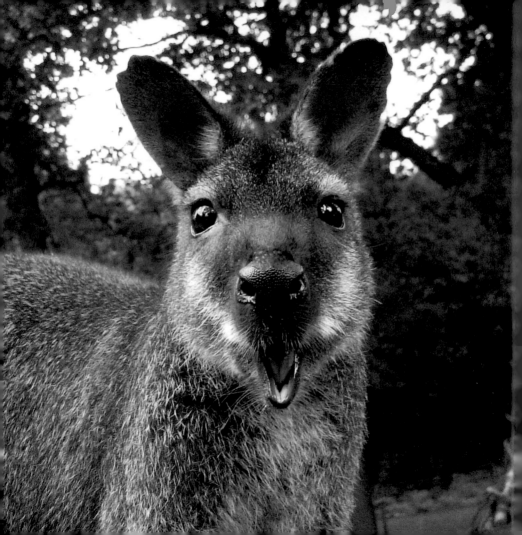

I MEAN, I'VE GOT A

TUFT OR TWO,

BUT THAT'S *INSANE.*

PUT IT AWAY... IT'S NOT BIG AND IT'S NOT CLEVER.

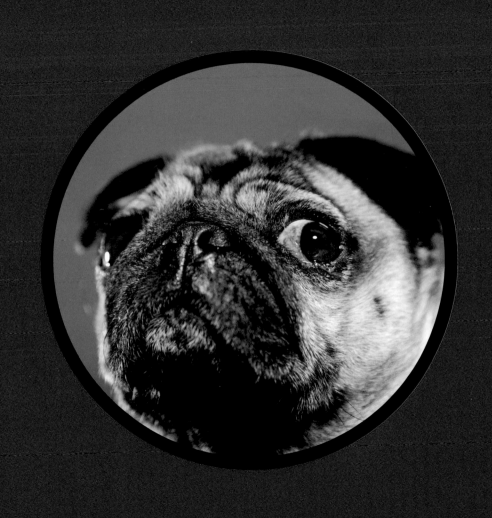

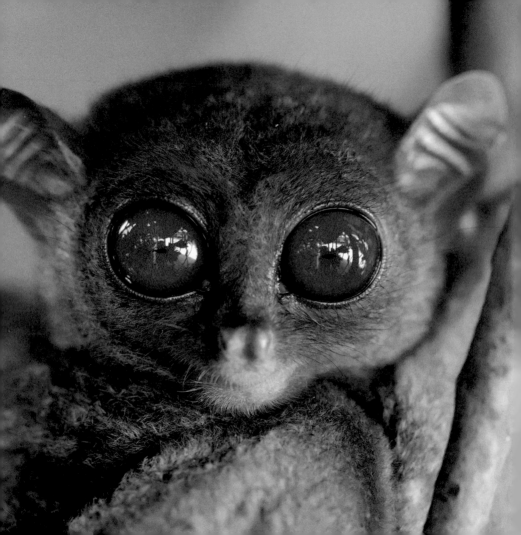

THAT'S SEARED ON TO MY

RETINAS NOW.

IF I CLOSE
ONE EYE
IT ONLY LOOKS
HALF AS BAD.

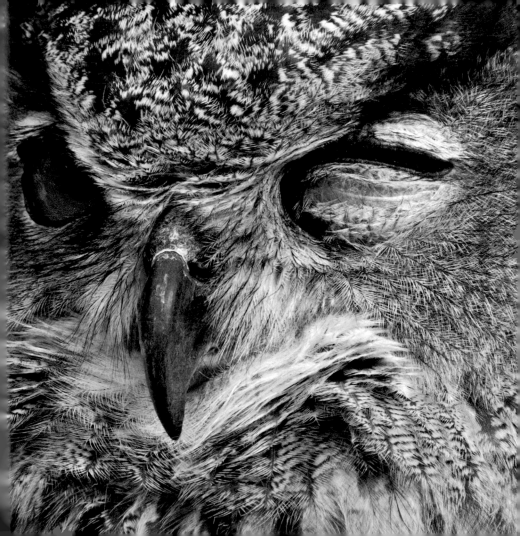

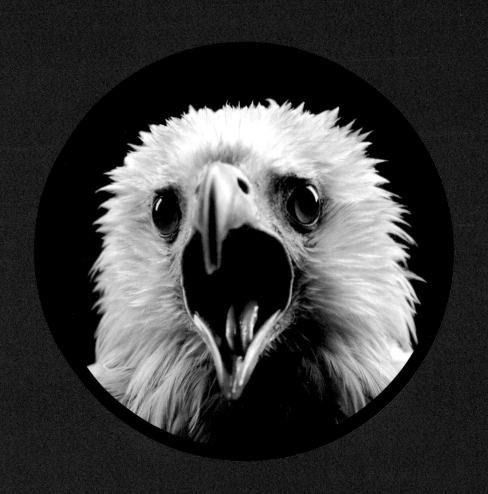

THERE SHOULD BE A

PARENTAL ADVISORY LABEL

ON THAT KIND OF THING.

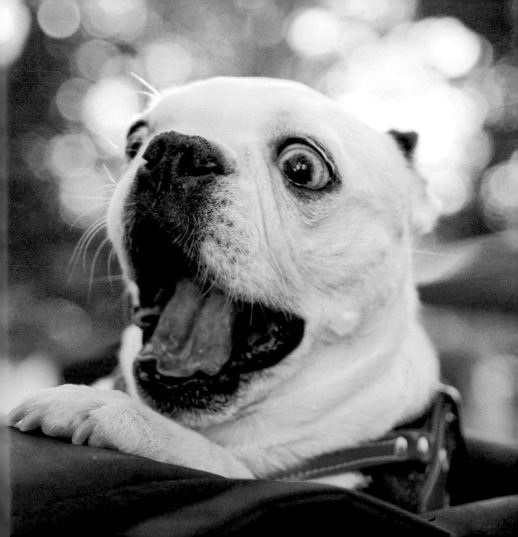

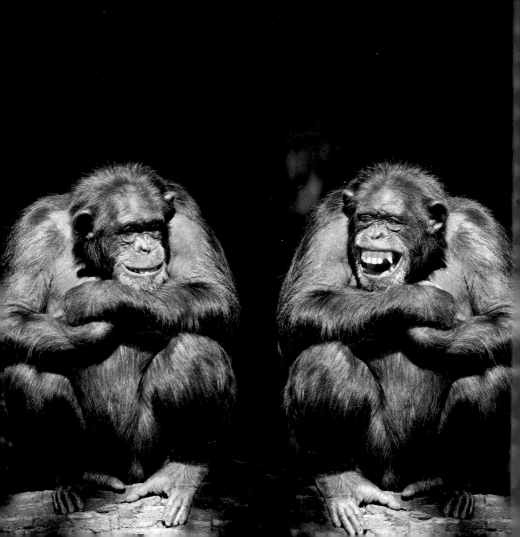

'SHE WAS TRYING TO COVER UP

LIKE THIS.

IT WAS HILARIOUS.'

CAN'T. CLOSE. EYES. CAN'T. NOT. SEE.

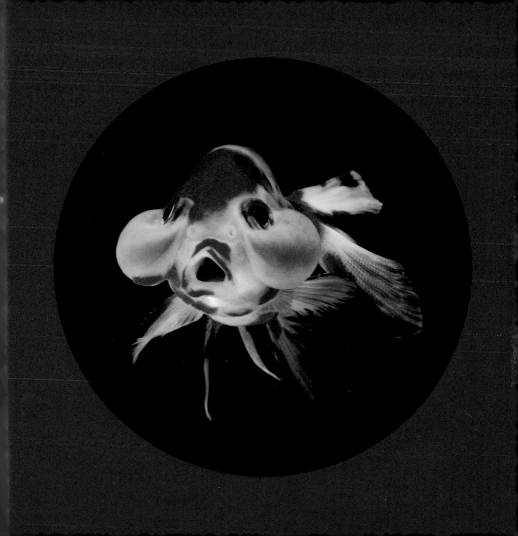

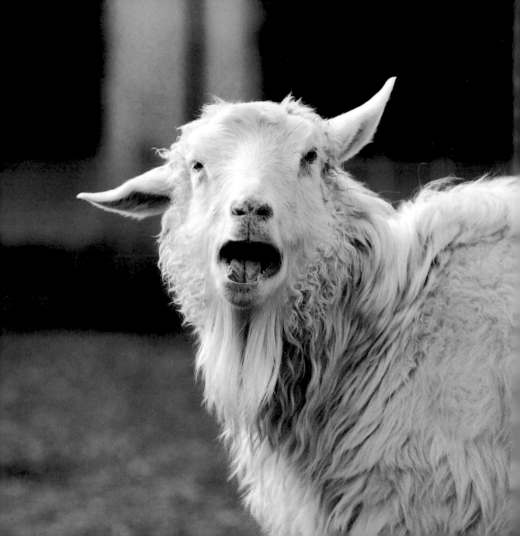

OH MY GOD,

LOOK AT HER BUTT.

WHO'S CUTE? A CLUE:

NOT YOU.

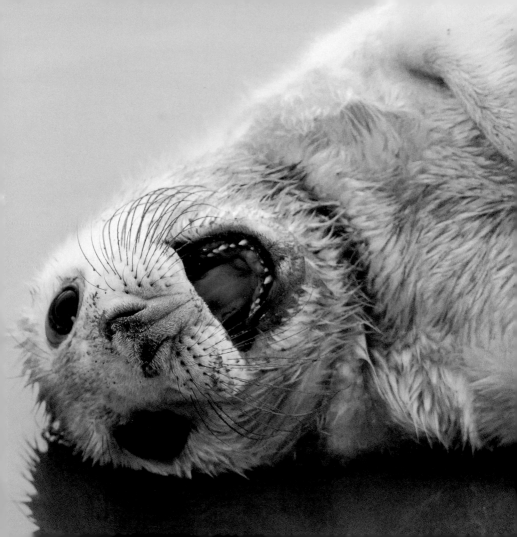

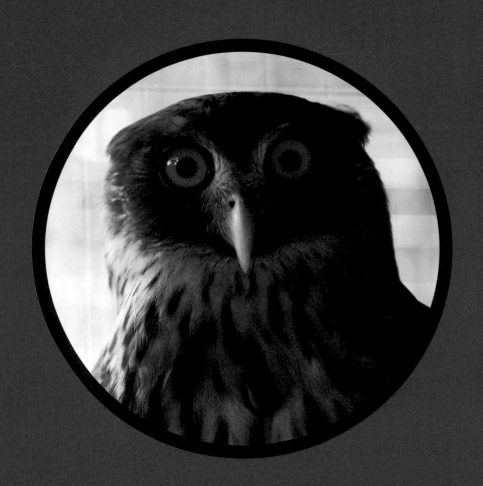

I SAY!

OH MY GOD, THAT IS FREAKING

HILARIOUS!

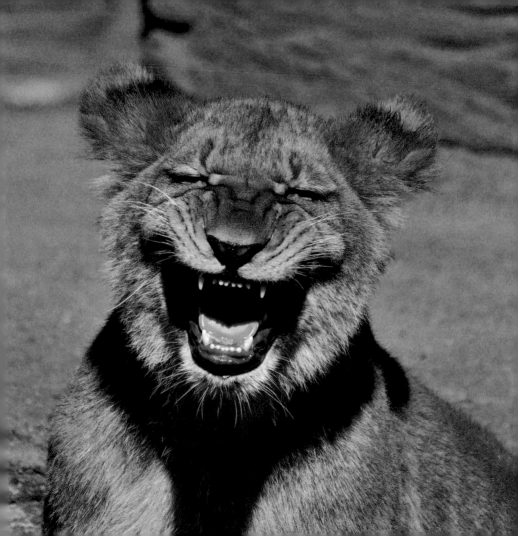

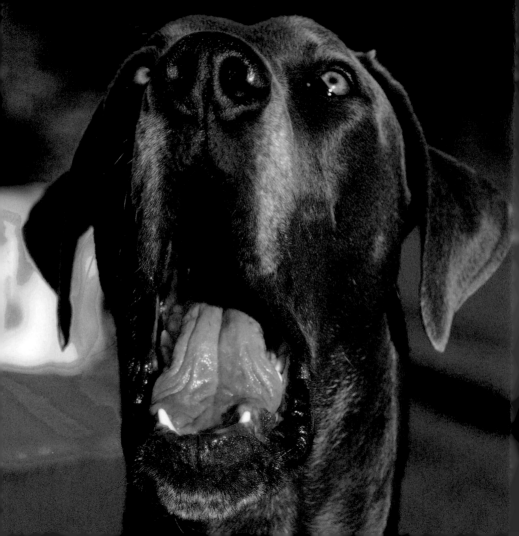

I THINK MY JAW JUST

DROPPED
SO FAR

I CAN'T GET IT BACK UP AGAIN.

WHOA – IS THAT REAL?

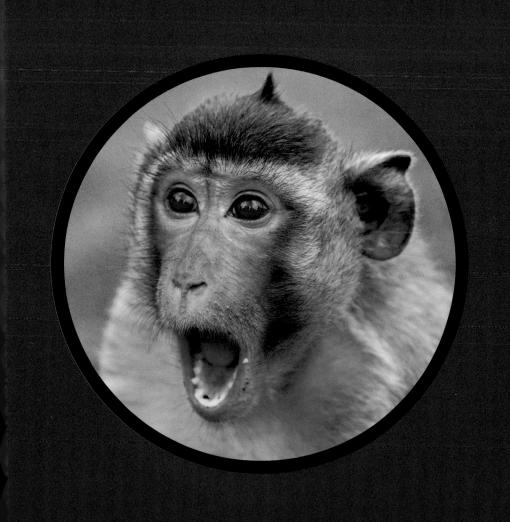

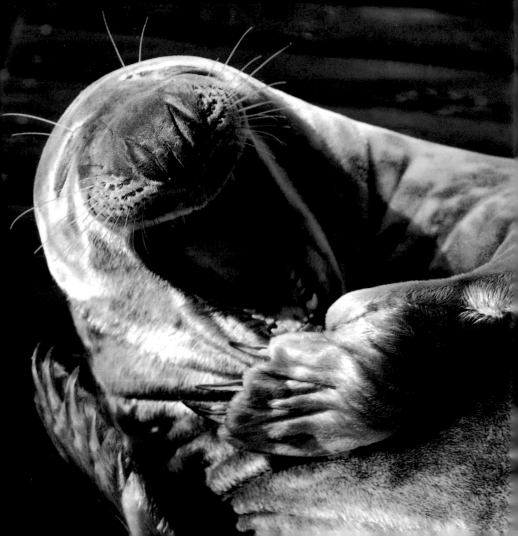

I'M NOT LAUGHING

WITH YOU.

NO WAY. I'M LAUGHING

AT YOU.

YOUR WHITE BITS ARE

WHITER

THAN MINE!

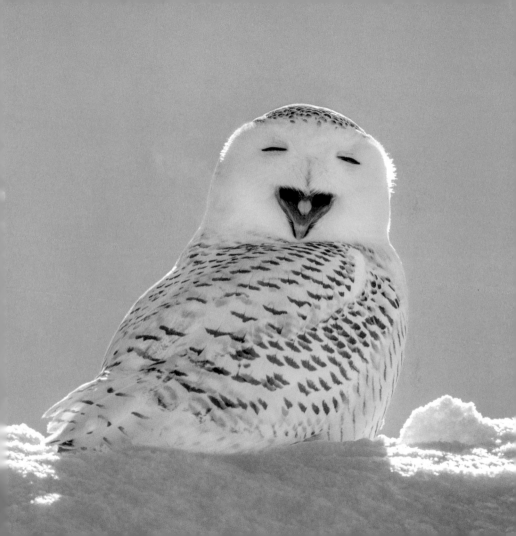

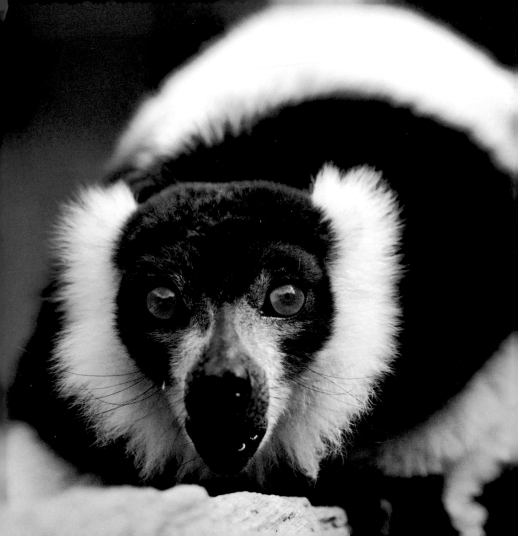

HOW DOES THAT
EVEN WORK?!

WAIT TILL I

TELL THE BOYS

ABOUT THIS ONE!

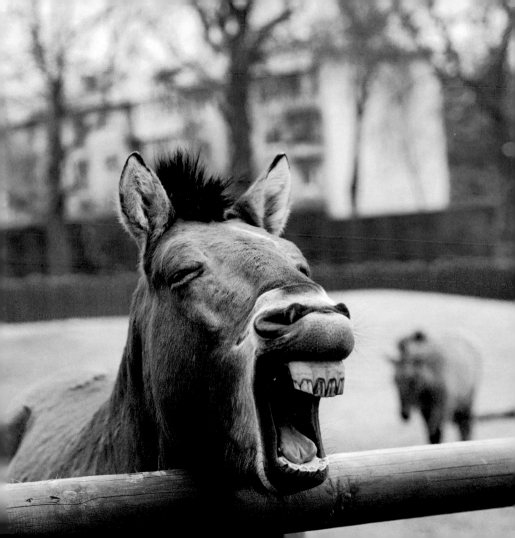

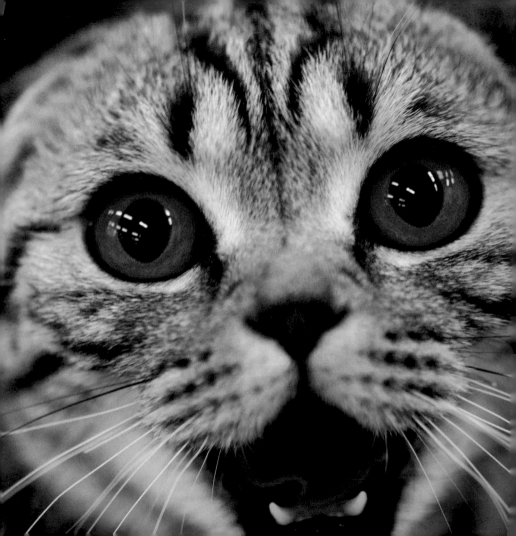

OH... NO...
YOU... DIDN'T...

OKAAAAY, I'M GOING TO STICK MY HEAD BACK IN THE SAND NOW.

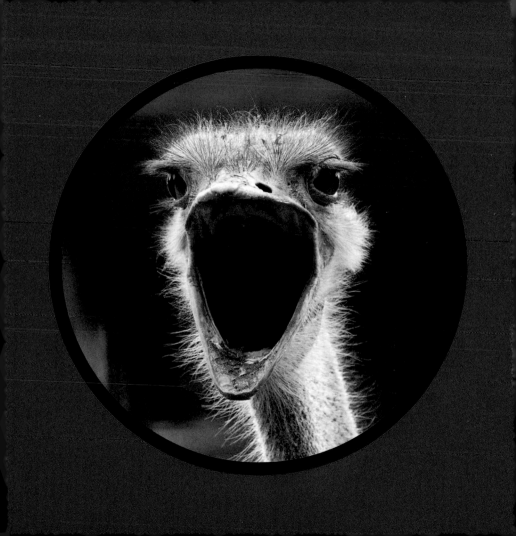

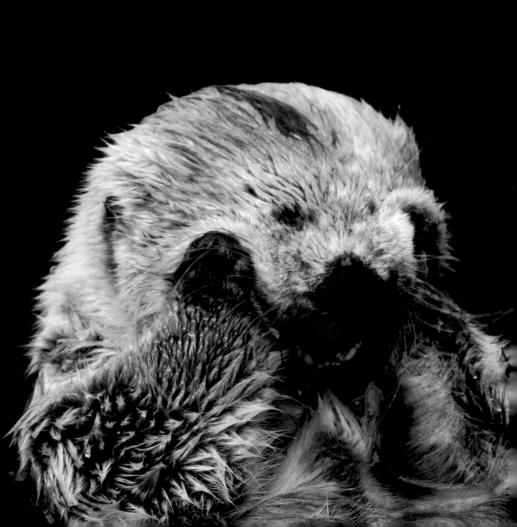

IT'S ALL
WET AND HAIRY!

THAT HUMAN'S NOSE IS IN THE

WRONG
PLACE

AND IS SO MUCH MORE WRINKLY!

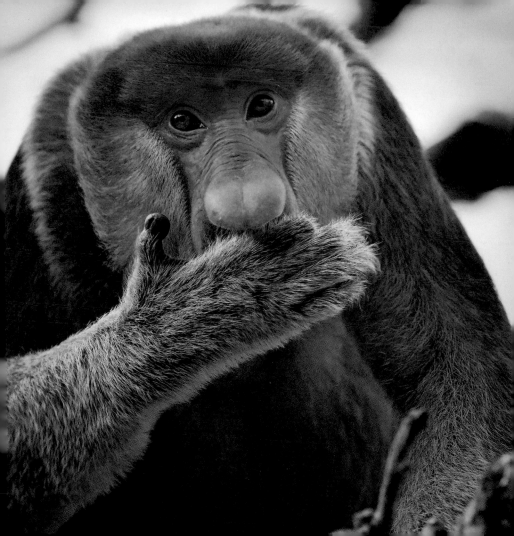

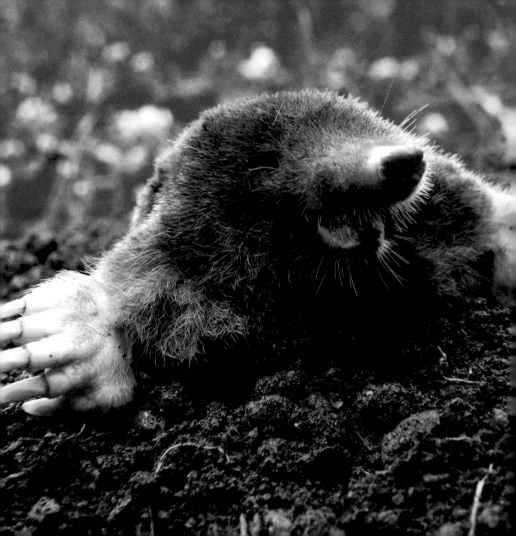

I JUST *HAD* TO

COME UP

FOR THIS!

GUESS I'M NO LONGER THE

FURRIEST

PUSSY IN TOWN...

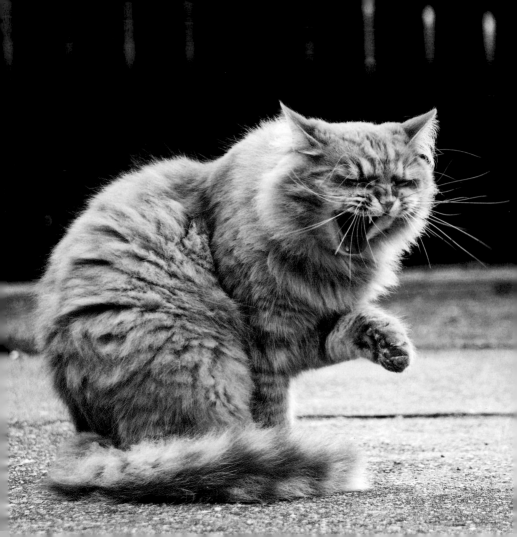

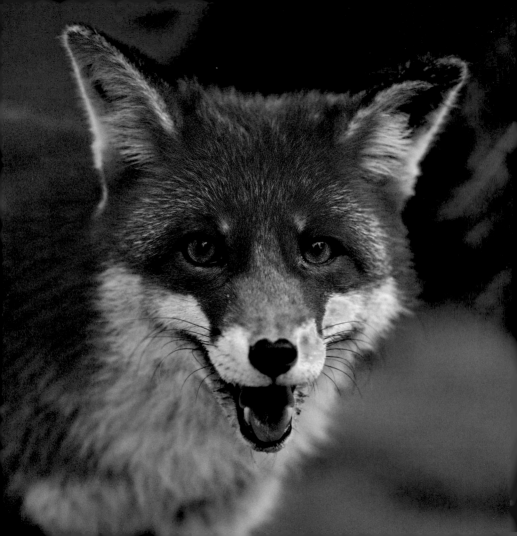

EH?!

LOOKING AT THAT MAKES ME WISH I HAD MORE EYELIDS I COULD SHUT.

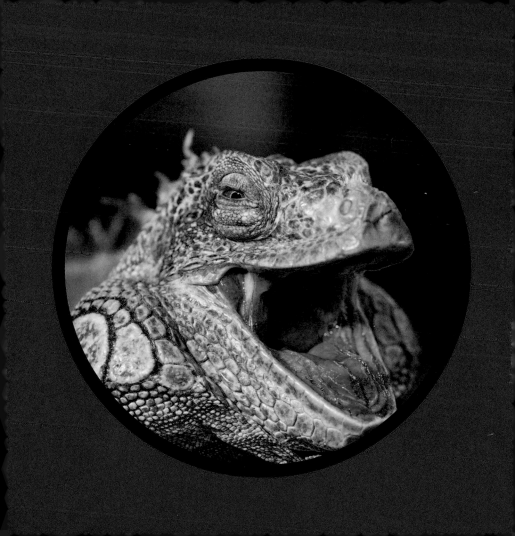

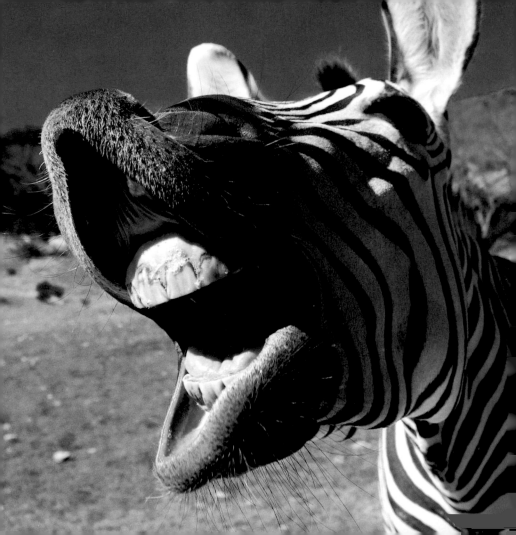

WOW.

JUST WOW.

AND I THOUGHT
MY BACK
WAS HAIRY!

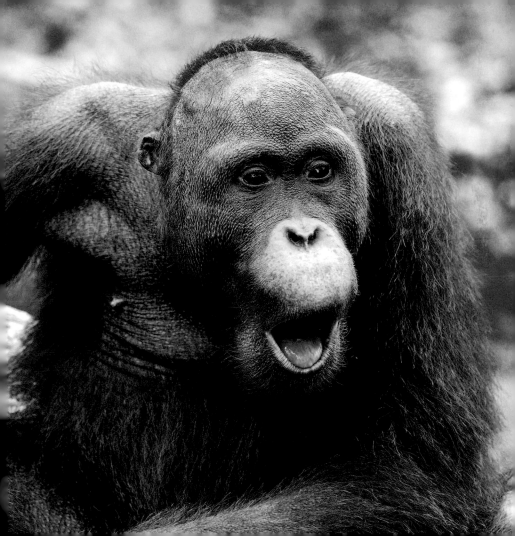

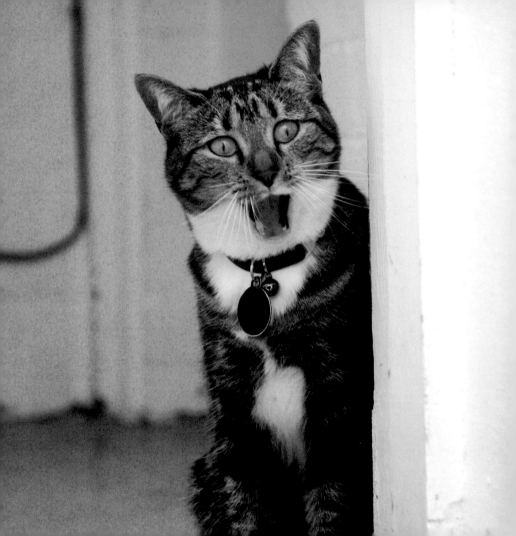

WHEN WILL YOU
REALISE
THAT I SEE EVERYTHING?
EVERYTHING!

I SHOULDN'T LOOK –

BUT I CAN'T

LOOK AWAY.

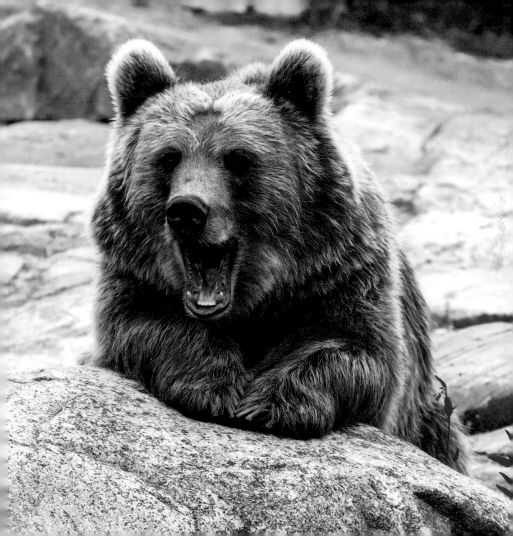

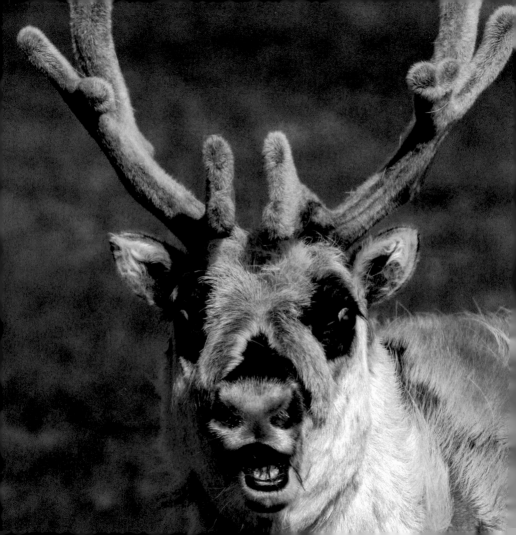

FUZZY, STUMPY AND NOT

FULLY GROWN.

AND I'M NOT TALKING ABOUT ME,

BUSTER.

I JUST THREW UP MY

OWN TONGUE

FROM SEEING THAT.

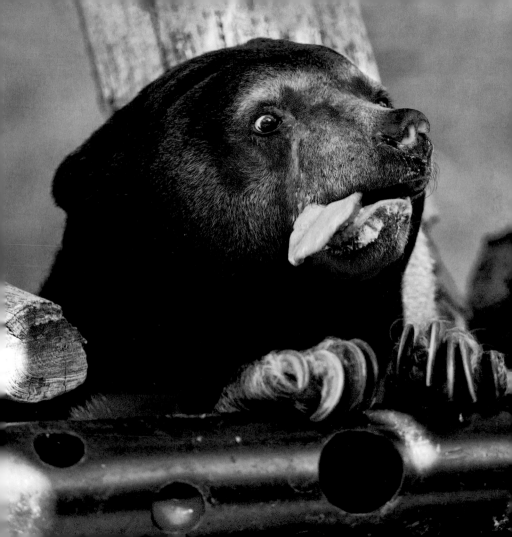

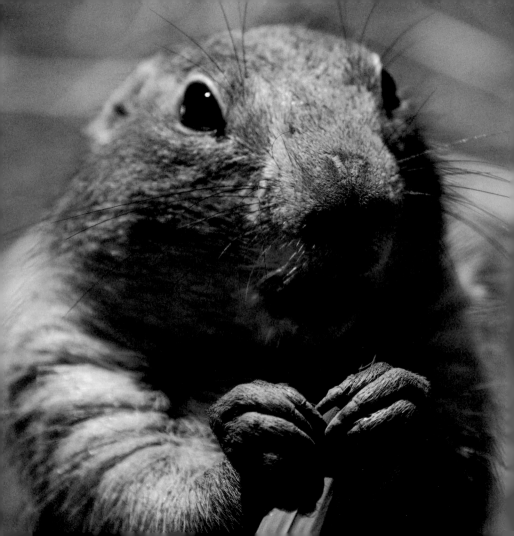

FORGIVE ME

MY SINS

FOR I REALLY

DO NOT

DESERVE TO SEE THIS.

IS THAT EVEN LEGAL?

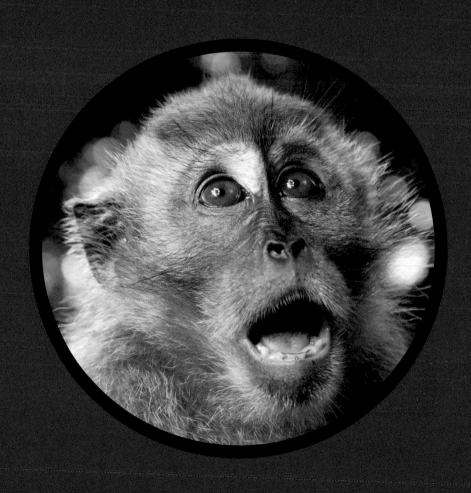

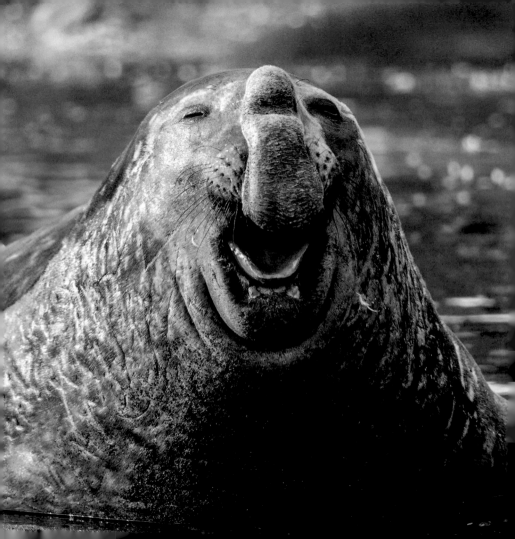

I'D PUT THAT ON

YOUTUBE

IF ONLY I HAD OPPOSABLE THUMBS...

AND A PHONE.

THAT'S A SIGHT TO MAKE EYES SORE!

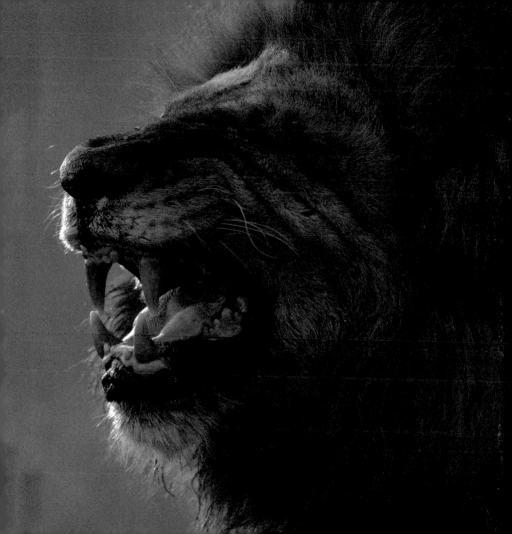

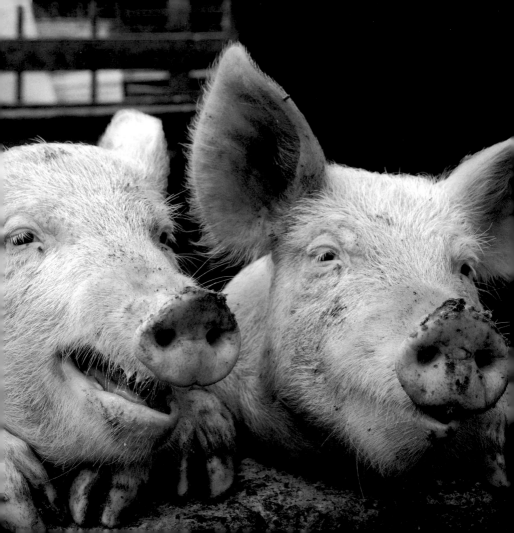

AND I THOUGHT WE WERE

A RIGHT PAIR...

HEAR NO EVIL, SEE NO EVIL,

SPEAK NO EVIL.

OH GOD, I CAN STILL SEE THE EVIL!

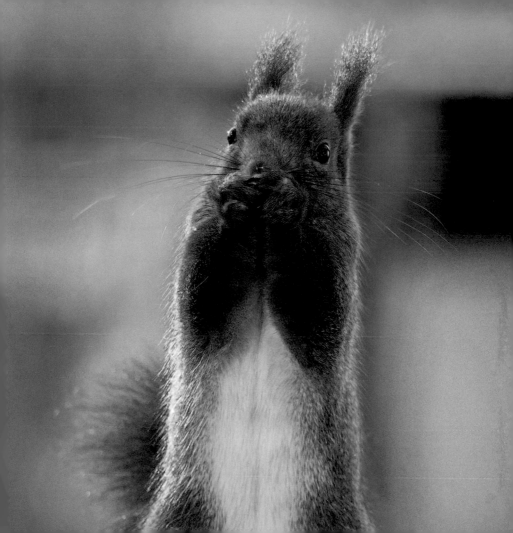

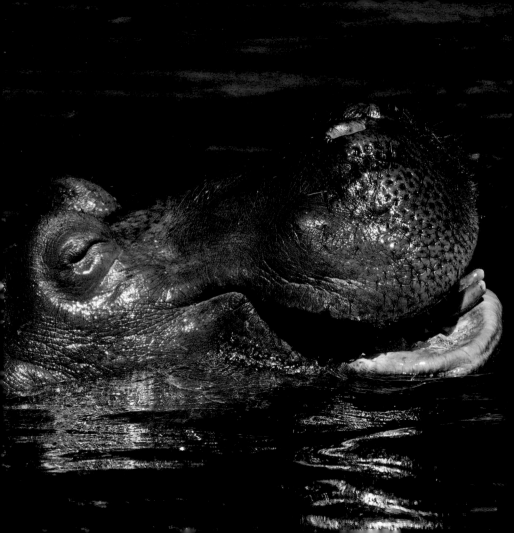

OH BOY, I DIDN'T KNOW THEY

MADE THEM

LIKE THAT ANY MORE.

I WAS JUST SICK IN MY MOUTH.

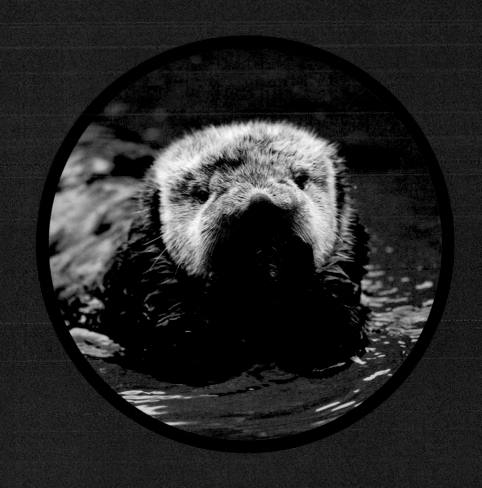

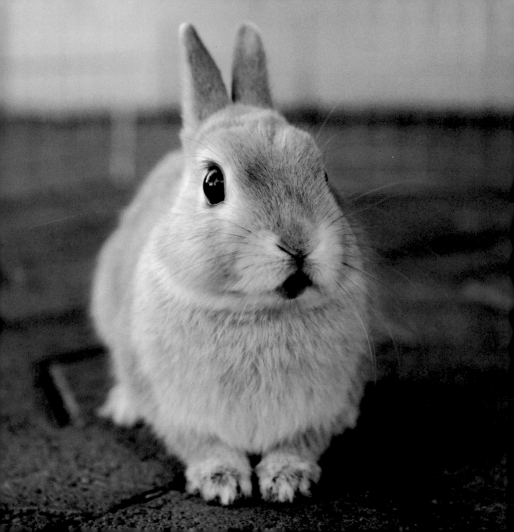

CRIPES!

OH, HELL
NEIGH!

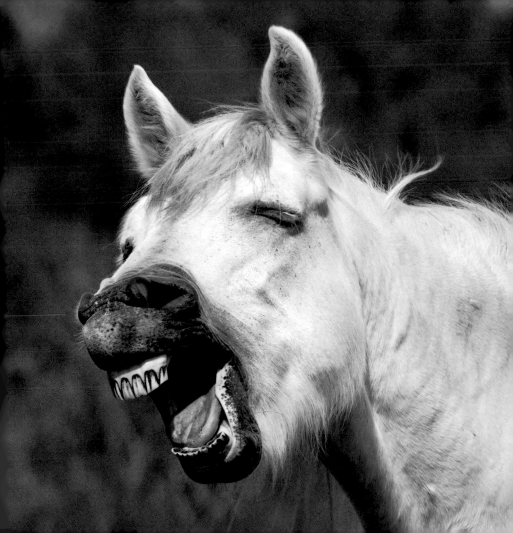

PHOTO CREDITS

ANIMAL SELFIES

CHARLIE ELLIS

ANIMAL SELFIES

CHARLIE ELLIS

ISBN: 978 1 84953 766 7
HARDBACK
£6.99

THE SELFIE CRAZE HAS REACHED THE ANIMAL KINGDOM! HERE ARE THE BEST PHOTOS OF CREATURES GREAT AND SMALL WHO HAVE TAKEN THEIR LOVE OF A GOOD PICTURE INTO THEIR OWN CLAWS, FLIPPERS AND HOOVES.

If you're interested in finding out more about our books, find us on Facebook at **SUMMERSDALE PUBLISHERS** and follow us on Twitter at **@SUMMERSDALE**.

WWW.SUMMERSDALE.COM